The Library
of Tattoos
and Body
Piercings

A Cultural History of Tattoos

Other titles in the Library of Tattoos and Body Piercings series:

The Library
of Tattoos
and Body
Piercings

A Cultural History of Tattoos

By Gail B. Stewart

ReferencePoint
Press®

San Diego, CA

© 2014 ReferencePoint Press, Inc.
Printed in the United States

For more information, contact:
ReferencePoint Press, Inc.
PO Box 27779
San Diego, CA 92198
www.ReferencePointPress.com

LIBRARY OF CONGRESS CATALOGING-IN-PUBLICATION DATA

Stewart, Gail B.
 A cultural history of tattoos / by Gail B. Stewart.
 pages cm. -- (The library of tattoos and body piercings series)
 Includes bibliographical references and index.
 ISBN-13: 978-1-60152-560-4 (hardback)
 ISBN-10: 1-60152-560-5 (hardback)
 1. Tattooing. 2. Tattooing--Social aspects. I. Title.
 GT2345.S76 2014
 391.6'5--dc23
 2012050782

Contents

An Enduring Tradition

Suzanne Kennedy is often asked about the large tattoo on her right bicep. It is a colorful growling tiger with an outstretched paw. Kennedy says she gets many comments on the art, especially from other women. Many are curious about what would motivate a woman in her fifties to get a tattoo—especially one that is so large and visible. She explains that she got the tattoo after her husband was killed by a drunk driver three years ago. Numb with grief, she knew her three young children depended on her. At first she was depressed and afraid that she could not be strong for them. Kennedy decided to do something very unusual to get through her depression—she got a tattoo.

She chose a tiger tattoo because her husband, Tom, had donated money to save tigers worldwide, and also because tigers are a symbol of strength: "[The tiger tattoo] is a permanent reminder that I must stay strong for myself and my children. I think of it as an inspiration and a protector. Sometimes I forget about the tattoo, until I catch a glimpse of it in the mirror. But I've never regretted it, not for a single minute. And I do take a lot of pride in being strong and fierce sometimes—to get us all through that horrible time."[1]

Uncommon and Frightening

Kennedy would have been a rarity in the United States 150 years ago. In the mid-1800s most Americans had never even seen a tattoo, except perhaps on circus performers. "A lot of people today don't know that there were hundreds of men and women in the mid-1800s to the ear-

ly 1900s who earned their living in what were called 'freak shows,'" says tattooist Chico Mason. "In those days, tattoos were something most people had only heard about, so it was a big deal to see 'The Tattooed Lady' or someone who was billed as 'The World's Most Tattooed Man.'"[2]

James F. O'Connell was the first tattooed man ever to be exhibited in the United States. O'Connell had lived among the indigenous people of the Caroline Islands in the western Pacific and had been tattooed all over his body while there. While no drawings of his tattoos have survived from that time, an engraving of O'Connell shows that his arms were tattooed with geometrical designs—a style of tattoo common in the Carolines. When he appeared at P.T. Barnum's Circus Museum in New York in the 1840s, crowds were both fascinated and frightened by his tattooed skin. According to tattoo historian Juniper Ellis, even when seen on the streets of New York, O'Connell was a terrifying sight to many. "Women and children ran screaming from him," she says. "Ministers had warned from the pulpit that viewing the designs would transfer them to any woman's unborn child."[3]

By the 1860s, however, sailors and others who had traveled to far-off places where tattooing was common were returning home with tattoos. Soon tattoo parlors began popping up in American port cities like New York and Boston. Since they tended to be in more unsavory places in the city, and because the art was usually associated with rowdy sailors or lawbreakers, tattooing was viewed as taboo by reputable people. Over the years "getting inked" became attractive to an even wider group of people—musicians, athletes, artists, and a range of others who enjoyed expressing themselves in a new way.

Tattoos Go Mainstream

In the twenty-first century tattooing has become mainstream—popular throughout the general population, from eighteen-year-olds to their grandparents. New York City tattoo artist Claire Vuillemot says her

clients range "from artists and younger people all the way to doctors, lawyers, architects."[4]

According to a 2012 Pew Research Center survey, more than 45 million Americans have at least one tattoo. And they are spending a significant amount of money on those tattoos—an estimated $1.6 billion annually, which means brisk business for the nation's more than twenty-one thousand tattoo establishments.

Tattoos mean different things to different people. To one woman, a tiger tattoo symbolized strength in the face of loss. For the man pictured here, a growling tiger and other colorful tattoos on his arm and shoulder may have held other meanings.

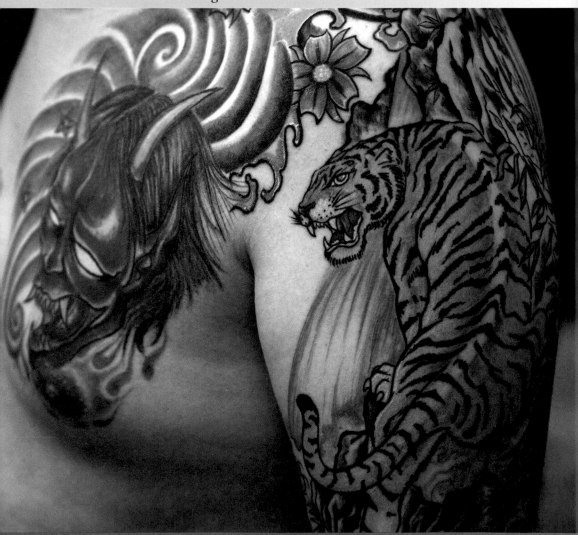

But the current tattoo trend is only the latest example of a long-running human fascination with the art of tattoo. Anthropologists have found that long before tattoos became circus attractions or body art for modern teens and young adults, they were a vitally important aspect of cultures throughout the world. In fact, historical evidence suggests that people have been getting tattoos since prehistoric times.

An Ancient Art

No one knows for certain when tattooing first took place. However, certain archaeological finds indicate that tattooing might have occurred in Europe as much as twelve thousand years ago. In France archaeologists have uncovered prehistoric stone pillars dating back to 10,000 BC. They show drawings of people whose skin is adorned with what appear to be various tribal emblems. In 1867 archaeologists found sharpened instruments made of flint as well as bowls containing traces of black and red pigment used in tattooing in what is known as the *Grotte de Fées* (Fairy Cave) in the French town of Châtelperron. Similar finds have been made in caves in Scandinavia and Portugal.

But the most exciting finds have involved mummified human remains with tattooed skin still visible. In 1991 the five-thousand-year-old remains of a tattooed man were discovered in the mountains between Italy and Austria, and in 1993 a tomb was uncovered that contained the twenty-four-hundred-year-old tattooed remains of a woman in Siberia. These finds are proof that tattooing has been practiced throughout much of human history.

Tattooing traditions vary from one culture to another. Those traditions laid out rules for deciding who got tattooed and when, with what tools, and what sort of ceremony would accompany the event. For some cultures in New Guinea and South Africa, getting a tattoo was a rite of passage, a way for young people to show their community they were ready to assume the role of adults and providers. For others, such as Inuit women living near the Arctic, a tattoo was seen as a way to be more attractive to men. Occasionally, as in ancient Rome, tattoos were even used to mark a person as a criminal or outcast.

Today, as the demand for tattoos has expanded, the methods have evolved with more precise equipment, more vivid inks, and with sterile facilities. But while much has changed, the reasons for acquiring a permanent design or image on one's skin are often very much the same as they were for those people whose lives revolved around tattooing rituals thousands of years ago.

Marking Life's Transitions

Dating back to ancient times, societies have marked the transitions from one stage of life to another with various rituals known as rites of passage. Many cultures throughout the world have celebrated these transitions with tattoos of special images or designs.

Important Moments

Sometimes the occasion was joyous, such as a birth. For example, centuries ago among the Opata people of northern Mexico, a new mother would tattoo dark spots around her newborn's eyes to form an arch shape. Over the years as the child grew, the mother would add to the number of tattooed dots, so that they gradually extended from the face all the way down the child's body to the legs.

Puberty, the time when a child begins to cross the threshold to adulthood, has also often been celebrated with tattoos. As recently as the twentieth century, Inuit girls were expected to get tattoos on their chin and cheeks at puberty. The designs were viewed as pleasing to men. However, there was another important reason for young women to receive tattoos. The ability to endure the pain of facial tattooing was considered proof that in the future they would be capable of tolerating the pain of childbirth.

Sometimes a rite-of-passage tattoo ceremony was held at a particular age. Other times the tattoo was done after a certain accomplishment, such as the first kill on the battlefield by a young warrior or the first whale or seal taken by a young Arctic hunter. In some cases a death in

the community was an occasion for survivors to get tattooed. Whatever the stage of life, many early societies throughout the world marked these rites of passage with a tattoo ceremony.

Scar Tattoos in West Africa

Some cultures continue to practice an ancient tradition known as scar tattooing, or or scarification. Scar tattoos are more common in African than European societies; the raised scars are far more visible on darker-skinned people than traditional ink tattoos. Unlike other tattoos that rely strictly on ink or other pigment to add color to the tattoo, scarification is made up of hundreds of small cuts—usually on the chest, abdomen, or back. Sometimes tribal tattooists rub charcoal or soot into the cuts, which become irritated and swollen. Over time, as the cuts scar over, the tattoo becomes more prominent. With or without pigment added, the resulting scars form raised, intricate designs.

In the remote villages of the West African country of Benin, the Bétamarribé people still practice centuries-old scarification rituals to mark the official beginning of childhood—usually when a child turns two or three. According to anthropologist and tattoo expert Lars Krutak, host of the Discovery Channel's *Tattoo Hunter*, this tattooing is not for looks but rather is a way of appeasing the ancestors of the tribe. In 2008 he wrote about the process after living among the Bétamarribé people. "The elders say that a child without these cuts is not 'human,'" he explains, "and if they don't receive the cuts, or if the child dies before he or she is able to receive their tribal markings, they are not buried in the village cemetery because they are 'not Bétamarribé' in the eyes of the ancestors."[5]

The ritual, notes Krutak, is difficult for an outsider to watch; parents and other villagers hold the child's arms and legs while the tribal scarmaster carries out the procedure. "Every child I witnessed being cut screamed and writhed in pain," writes Krutak. "One passed out halfway through the cutting, but he regained consciousness towards the end and resumed his bloodcurdling cries."[6]

Between the ages of seven and twelve, there is another rite-of-passage scarification ceremony. This

Did You Know?

The first electric tattoo gun was invented in 1871 by New Yorker Samuel O'Reilly.

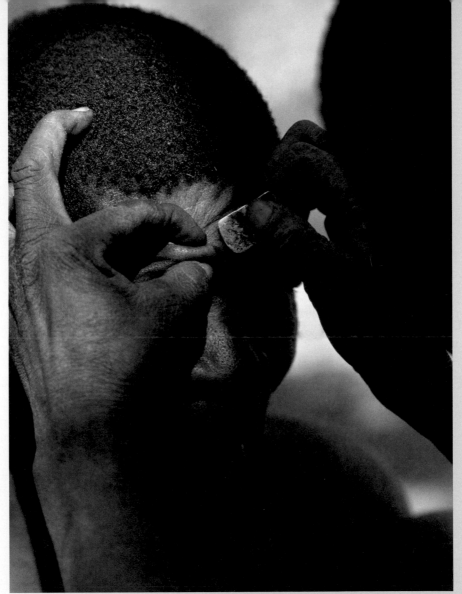

A man undergoes the painful process of scarification. Using a sharp piece of metal, his wife makes cuts in his forehead. The wounds from the cuts are sealed with animal fat and herbs to create a raised pattern on the skin.

time the cuts are made on the abdomen for a boy, and on the back for a girl. Finally, at age fifteen each girl must receive incisions on her lower abdomen, near the kidneys, and on the buttocks. After having this extensive scarification, the girl is considered an adult and able to be married.

While many modern Bétamarribé live in cities and do not practice scar tattooing, it remains an important part of the culture. And some

young Bétamarribé hope to carry on the tradition. "When I was young, I saw that my grandparents had [the scars] and I thought they were beautiful," says Clarisa, a tattooist who has decided to continue the family tradition. "When I have children I will encourage them to also get these scars, because I want them to carry on the Bétamarribé culture and tradition."[7]

Mocked for Being Afraid

In the mid-1700s missionary Martin Dobrizhoffer lived among the Abipoines, an indigenous people of Paraguay. He found that the Abipoines held rite-of-passage tattooing ceremonies when women were old enough to be married. In his book *The History of Tattooing and Its Significance*, anthropologist W.D. Hambly explains there was little sympathy or understanding from elders when the young women were frightened.

> The Abipoine women are not content with marks common to both sexes, and have the face, breast, and arms covered with black figures of various shapes. . . .
>
> The higher their rank, and the greater their beauty, the more figures they have; but this . . . ornament is purchased with much blood and many groans. As soon as a young woman is of age to be married, she is ordered to be marked according to custom. Her head rests on the lap of an old woman, thorns are used for a pencil, and the pigment is ashes mixed with blood. If the wretched girl does but groan or draw her face away she is loaded with reproach, taunts, and abuse. "No more of such cowardice," exclaims the old woman in a rage. "You are a disgrace to your nation." "You will die single, be assured." "Which of our heroes would think so cowardly a girl worthy to be his wife?"

Quoted in W.D. Hambly, *The History of Tattooing and Its Significance*. London: H.F. & G. Witherby, 1925, pp. 42–43.

Coming-of-Age Tattoos in the South Pacific

In the Marquesas Islands, a group of small volcanic islands in the South Pacific, tattoos were once an important part of life, especially for girls. As recently as the 1920s, girls were expected to perform certain sacred rituals by the time they turned twelve. These included cooking *popoi*, a traditional dish of mashed breadfruit, as well as preparing a dead family member for burial by rubbing coconut oil on the skin. Without the traditional tattoo on her right hand, a girl was not permitted to do these jobs, which would bring shame to her and to her family.

Unlike Marquesan girls, the boys had no required tattoo. However, many wealthy families considered tattooing an important rite of passage for the eldest son before he was considered a man. The tattooing was extensive, and, depending on a boy's tolerance of pain, the process might take months to complete. As tattoo historian Maarten Hesselt van Dinter notes, the tattoo ceremony was both elaborate and expensive:

> A house was even constructed for the occasion with wood stripped from the father's house. A group of at least 40 young men helped build the house, and as a reward, each of them was tattooed at no cost to themselves while the oldest son recovered between sessions. . . . All involved had to be provided with food for the duration: the helpers, the family itself, and the tattooists and his assistants. The tattoo artist, *tuhuna,* as he was called, also expected generous compensation in the form of gifts.[8]

Tattoo Equipment of the Marquesans

The tattoos were done with two tools that could be modified, depending on how extensively the person was to be tattooed. For example, in the case of the eldest son tattoos, the tattooist would use a special wooden comb fitted with three to six razor-sharp shark's teeth. For a smaller tattoo, such as one on the hand of a young girl, a stick with only one shark's tooth was used.

The black tattoo ink was made from vegetable juice mixed with the ashes of the large seeds of the candlenut tree. After dipping the comb's teeth into the ink, the tattooist would place the teeth on the skin and strike the comb with a mallet. The strokes of the mallet forced the teeth into the skin, leaving the ink behind in the bloody puncture wounds.

The process was painful—especially when the tattoo was on a particularly tender body part, such as the tongue or eyelids. Many tattooists sang soothing songs while they worked, hoping that the music would calm the subject and drown out the whacking of the mallet on the wooden comb. The finished Marquesan tattoos ranged from detailed geometric designs to images of birds or other animals.

Death Tattoos

Tattoos had meaning not only during a person's lifetime, however; in many cultures the tattoos one received in life would also have important meaning after death, too. Some cultures believed that safe passage into the afterlife could be accomplished only by those who had certain tattoos. For example, the Sioux people of what are today the states of North and South Dakota, Minnesota, and Iowa believed that after a warrior died his spirit traveled upward on a ghost horse to the afterlife. An old woman stood on the steep path leading to the afterlife, and she would stop each ghost as it passed by, demanding to see the necessary tattoos on his forehead or wrists.

If he had received no tattoos in life, or if the markings were not in the right places on his body, the old woman would block his entrance to the afterlife by pushing the warrior and his horse down from the cloud back to Earth. According to anthropologist W.D. Hambly, the luckless warrior and his horse would "become homeless wanderers who go about aimlessly, the warrior whistling, presumably to relieve his melancholy."[9]

The importance of tattoos in death also had a place in the Hindu culture of Bengal, India—especially among people of the lower social ranks, or castes. They believed that a woman who died without being tattooed

would not be recognized by her parents in the afterlife. And if she had no tattoos when the great god Parameshwar demanded to see them, she would be doomed by being forever reincarnated as an evil spirit.

Inuit Funerary Tattoos

The death tattoos of the Inuits, whose 2,000-year old tattooing traditions died out in the early twentieth century, had nothing to do with one's passage to the afterlife. Instead, their function was to protect certain people of the tribe after the death of one of their members.

The Inuits, who live in the Arctic regions of Alaska, Canada, Greenland, and Siberia, believed that each person was made up of many souls, which were responsible for feelings, warmth, thought, and language. Each of these souls resided in a particular joint of the body. When a person became ill, it was because one of the souls had abandoned that joint. No part of the body was more susceptible to illness than a person's joints.

The death of a tribal member was a particularly dangerous time for the rest of the community, for the spirit of the deceased lingered in the vicinity of his or her home for some time. Those spirits could enter the body through the joints. That meant that anyone who came into contact with the dead body was at serious risk—especially the pallbearers who would carry the body to the burial site. Because of this risk, the tribal tattooist would tattoo each of the pallbearers' joints to protect them from being overwhelmed by the evil spirit.

Sewing Tattoos

The Inuit method of tattooing was also unusual. Rather than cutting or pricking the skin and rubbing pigment into the wounds, the Inuit tattoos were actually sewn into the skin. Women were the tattooists, largely because of their skill and experience sewing clothing and boots made of animal hides, which have a similar texture to human skin. The needles they used were made of bone or, occasionally, steel, and the thread was actually a string of sinew from a reindeer or whale.

The ink was a mixture of soot, seal oil, and urine. The urine was valuable for two reasons: it contained ammonia, which made infections from the tattoo less likely, and it also was believed to repel evil spirits. After soaking the thread in ink, the tattooist would lift a fold of skin near one of the joints and pass the needle and thread through one side and out the

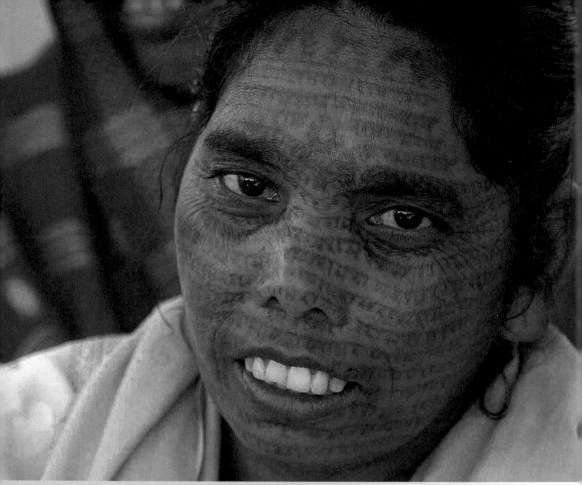

The name of a mythological Hindu god is tattooed across the face of a woman from a low caste in India. A woman who died without such tattoos, it was believed, would not be recognized by her parents in the afterlife.

other. As the thread passed though, it left behind two dark spots under the skin. Those spots are the tattoo that protects the person's joint from being invaded by the evil spirits.

Rites-of-Passage Tattoos Today

Rite-of-passage tattoos are no longer the domain only of tribal cultures. In the United States and in many European countries, some young people think of getting a tattoo as a way of marking their independence as young adults. Holly, a nineteen-year-old college student in St. Paul, Minnesota, is proud of the tattoo she got on her eighteenth birthday—when she bacame legally able to get a tattoo. And as she explains, the im-

age was not as crucial as was the experience of getting the tattoo. "I had it all planned out," she says:

> I knew I wanted to get an American flag, because my brother Eric is serving in the Navy. I found out how much it would cost, and saved for it. I don't regret for a minute that I did it—unlike a lot of people I know who went out and got their boyfriend's name or something. Just the experience of doing it without asking anyone's permission—that was a big step for me, just doing something brave, enduring the discomfort on my own, not wimping out. I was actually really proud of myself—that was my rite of passage, I guess.[10]

Bergen, a college anthropology student, agrees that a tattoo is often seen as a rite of passage among older teens:

> We've got built-in transitions nowadays, like getting your driver's license when you turn 16, or going to your school prom, or having a bar mitzvah or confirmation or whatever. But to me, a tattoo is a more permanent reminder of moving from one phase of your life to another. You don't look at your driver's license and reminisce about transitioning from being a walker to being a driver. But a tattoo is different—it's a personal statement of who you are, at that moment in time.[11]

Transforming Scars to Beauty

Some tattoos commemorate the transition between an unpleasant or scary part of one's life to a more positive one, as California attorney Mary Lynn Price learned firsthand. Though she had never planned to get any tattoo—let alone a rite-of-passage tattoo—Price found that the rite was just what she needed. Her tattoo became a symbol of her transition from a life-changing illness to confidence and health.

After Price had emergency surgery for a life-threatening medical condition, she had a very noticeable scar across her abdomen. Although she was not

A Brave, Tearful Rite of Passage

Ellen, twenty-seven, suffers from social anxiety. She gets a lot of comments on the tattoo of a black Labrador retriever on her arm. She has always loved that dog whose name was Ed, but says the tattoo is more to mark a heartbreaking but important day in her life, the day Ed died. "Ed was my best friend, for most of my teen years and into my early 20's," she says.

> I am never comfortable socially, and very much of a chicken about getting out there and making friends. Anyway, Ed was totally cool with whatever I was. I always believed he could sense my daily discomforts, or my fears of new situations. He'd kind of lean into me, as if he was saying, "You're okay; you're with me."

> Ed lived to be twelve, which is pretty good for a lab. I panicked when the vet said he had cancer, and it would be best that we put him down. I thought, "We??" I could never do that. But I did. I loved Ed. I figured he'd done so much for me all these years, I owed him to be brave. So I sat down on the floor with Ed and rubbed his head when he had the shot, and it was over fast. I cried, and the vet's nurse did, too.

> A week later, I did the second bravest thing by getting a tattoo of Ed. I have it inside my arm so I can look at it, and know that I can do difficult things sometimes. Ed taught me that.

Ellen, personal interview with author, December 15, 2012, Minneapolis, MN.

terribly bothered by the scar at the time, she happened upon a story about a woman who had had a mastectomy after being diagnosed with breast cancer. Later, the woman had decided to get a lovely tattoo of a flower and vine to mask her scar, and that idea appealed to Price. To her,

getting a beautiful tattoo at the site of her scar was very much like a transition from a period of trauma to a time of beauty:

> I just thought, wow, that's an incredible transformative way to deal with what was probably a very upsetting scar for her, and a scar that was part and parcel of a very traumatic situation. So it sort of planted the idea in my mind that a tattoo is one artistic way to deal with that. And little by little, I began to think more and more about could I come up with a tattoo design that would work for this particular area of my body and this particular little scar.[12]

Price had always loved birds, especially great blue herons. She worked on a rough sketch of a design and showed it to a tattoo artist, who then developed it further. The tattoo that Price ended up with covered her scar with the arching wings of the herons. "The area where I had the scar before was always something that I was very conscious of," she says, "whether I was looking at it or not, I knew it was there. It was almost this blemish, this reminder of a very traumatic experience. And interestingly enough, it has been truly transformed into this incredibly beautiful artwork."[13]

Chapter Two

Tattoos of Belonging

Flynn, a twenty-five-year-old Minnesotan teaching in South Korea, wanted to feel closer to his two older brothers, though they were thousands of miles away. He decided to get a large tattoo on his right arm, showing three roses. Two of the roses have a brother's childhood nickname underneath; the third has his own nickname. He acknowledges that he gets many questions about the meaning of the tattoo—largely because in Korea tattoos are rare.

"When one of my students, or someone else asks, I explain to them that I miss my brothers," he says simply. "And unfortunately, because we live so far apart these days, we don't get to see each other very often. So now they're on my arm. [The tattoo] was a way for me to keep them close. To me, it really doesn't matter at all if other people understand it or not. The tattoo is part of me, and I'm glad I did it."[14]

Cultural Status

One of the most common reasons that people decide to get tattooed is to show their affiliation with a group. A tattoo—whether a picture, a symbol, or a name—is a way of proclaiming solidarity with one's family, homeland, a religion, a favorite sports team, or even a gang. In fact, anthropologists say that people throughout the world have been getting tattoos of affiliation since ancient times.

The earliest tattoos were likely symbols that identified people as belonging to a particular clan or tribe. Perhaps a prominent tattoo was an image of a design or animal sacred to the tribe. A tattoo could help clan members recognize one another more easily when engaged in battle, or when traveling in unfamiliar territory. Conversely, a tattoo might provide an alert that a stranger was from an enemy tribe.

Besides declaring an affiliation with a clan or tribe, some early cultures used tattoos to identify an individual's rank or status. For example, archaeological finds indicate that the Scythian Pazyryk people, nomads who once lived in the Altai Mountains in what is now southern Siberia, may have created their beautifully detailed tattoos to signify a person of high status. Ancient tattooed remains of a Scythian Pazyryk woman known by anthropologists as "The Ice Maiden" were found in 1993. Scientists have determined those remains date back twenty-four hundred years, to the fifth century BC.

The Ice Maiden was found in a large underground tomb called a *kurgan*. Just outside the tomb were the remains of six horses saddled and fitted with golden bridles. It appeared that the horses had been sacrificed and then lowered into the burial site. The archaeologists believe these finds mean that the woman must have been someone important. After carefully opening the tomb itself, they saw that water had leaked in and had frozen and preserved much of her skin. One of the archaeologists working the scene remembers the moment when they carefully pulled back her clothing and saw the tattoos: "[O]n her left arm, the right thumb, and then again on her left shoulder are these amazing tattoos. Creatures just in immediate action poses, and they are in fact twisted oddly at 180 degree angles. They have amazing horns that end in flowers, fantastic creatures. At that point the whole dig stopped and people came down and everyone was looking, not only was this a woman, but one with tattoos and they are quite elegant."[15]

Later, a more thorough examination showed other detailed tattoos of animals such as a red-antlered deer—likely her spirit, or totem, animal—that covered her shoulders and wrist. This body art, all done in charcoal-colored pigment, was a valuable find for researchers, for it was something never before seen on the remains found in other kurgans. The absence of tattoos on remains found inside other, smaller kurgans suggests that only people of importance in Scythian society—royalty, skilled healers, or even talented folktale tellers—received tattoos. The writings of an ancient

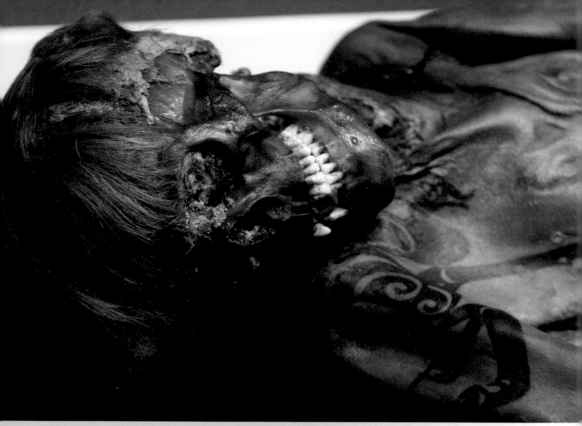

Tattoos are visible on and around the shoulder of a mummy of a Scythian warrior, displayed at a museum in Germany. Tattoos such as this signified a person of high status.

Greek writer, Herodotus, confirm this idea. In 450 BC he wrote that among the Scythians and Thracians, "tattoos were a mark of nobility, and not to have them was a testimony of low birth."[16]

"A Brotherhood of Pain"

In some tribal cultures the very experience of getting tattooed was viewed as a test of an individual's courage and inner strength. The process of having razor-sharp tools cutting into one's flesh and having dirt, charcoal-based ink, or other substances rubbed into the bleeding wounds was incredibly painful—sometimes resulting in infections, convulsions, high fevers, and even death. Those who endured the experience and survived found camaraderie with other tribal members who had done the same.

But there was a great amount of pressure on individuals—even young children—to go through the tattooing ceremony. For example, in Inuit cultures it was understood that children on the verge of getting their

tribal tattoo must overcome their fears. To refuse to participate in the ceremony would not only disgrace them and their families but would also deprive them of the feeling of belonging to the tribe that tattoos ensured. Refusal could also have painful consequences, as a line from a popular story warns: "Come now, child, if you won't let yourself be tattooed, terrible things will happen to you after you die. Evil spirits will take you and make a drip-tray of your skull to catch the fat from their oil lamps."[17]

Tattoo professional Max Wright says that getting a tattoo centuries ago was far more painful than getting one in a twenty-first century tattoo studio:

> It's not an overstatement that these tribal members who got tattoos back then were bonded for life—not just because of the shared symbol they had tattooed on them, but because they got through the pain without dying. I guess you'd call it really a brotherhood of pain. The thing is, they were using sharpened bird and animal bones to make the cuts, and rubbing that pigment into the open wounds—nothing like today's tattoo guns that inject the ink under the skin. When I'd read about these old tribal ceremonies, I'm amazed that more people didn't chicken out. I think those who did it and survived without dying from massive infections really felt that they were bonded, like soldiers that survive together against all odds.[18]

Early Witnesses

Many of the earliest Europeans to arrive in Central and South America described the variety of tattoos they saw among the native peoples, including sacred totems such as tortoises, toads, and alligators, or tattoos commemorating victories in battle. The visitors also noted that pain seemed to be an integral part of the tattoo process. Diego de Landa, a sixteenth-century Catholic bishop in the Yucatán Peninsula of Mexico, was one of the first to detail how the native peoples tattooed their bodies. In 1566 he wrote, "The more they were tattooed the more valiant and brave they were considered,

because the operation of tattooing was very painful. . . . They tattoo only a little at a time, because the pain is great. They also become ill, for there is inflammation, and matter gathers in the tattooing. In spite of this, they scoff at those who do not have themselves tattooed."[19]

Almost fifty years later French explorer Gabriel Sagard-Théodat spent time in what is now Canada, learning about the way of life of the Huron Indians he met. He was amazed at the bravery the Hurons demonstrated while getting their tribal tattoo: "During this process they exhibit the most admirable courage and patience. They certainly feel the pain, for they are not insensible, but they remain motionless and mute while their companions wipe away the blood that runs from the incisions. Subsequently they rub a black color or powder into the cuts in order that the engraved figures will remain for life and never be effaced."[20]

Adoption by Tattoo

In some cultures tattoo rituals were viewed as an official way of welcoming a new member to a tribe or family. Jean-Bernard Bossu, an eighteenth-century French adventurer, learned about this ritual firsthand. Bossu explored the Mississippi River Valley between 1757 and 1762. During his time in the region he was adopted into the Quapaw tribe, which lived along the west side of the Mississippi River in what is now the state of Arkansas. In his memoirs Bossu explains that getting a tattoo was a crucial part of the Quapaw adoption ceremony: "I underwent these painful procedures willingly. I was invited to sit on a tiger skin. One of the savages burned some straw and mixed the ash with water. He used this simple mixture to create the outline of a goat, then followed this sketch with sturdy needles, pricking them into the skin [of my leg], producing blood. This blood together with the straw ash produces an indelible image. Afterwards I smoked a pipe with them."[21]

Bossu writes that the tattoo not only made him an official Quapaw but also gave him the rank of warrior and chief. His new tribal family

assured him that if and when he encountered any of the Quapaw allies in his future travels, he merely had to show his tattoo and he would always be welcomed as a brother.

The Makonde Tattoos

For many centuries before the first Europeans arrived in Africa, the Makonde tribe of northern Mozambique in southeast Africa relied on

The Song of Chiefs

Samoa, a group of islands in the South Pacific, has a long history of tattooing. When anthropologist Karl Marquardt visited Samoa in the late nineteenth century, he reported on a special soothing song sung by the tattooist when he was tattooing a village chief or a relative of the chief. While the tattoo might not be different from that of a commoner, it was the tattooist's singing voice that was a clear signal that an elite member of the community was being tattooed. Below is a translation of the song's comforting words:

Patience. Only a short while and you will see your tattoo, which will resemble the fresh leaf of the ti-plant.

I feel sorry for you. I wish it was a burden which I could take off your shoulders in love and carry for you.

The blood! It springs out of your body at every stroke [of the hammering chisel]. Try to be strong.

Your necklace may break, the *fau*-tree may burst, but my tattooing is indestructible. It is an everlasting gem that you will take into your grave.

CHORUS: O, I am sad, you are weak, O I feel sorry that the pain follows you even in your sleep and you resist it.

Quoted in Steve Gilbert, *Tattoo History: A Source Book*. New York: Juno, 2000, p. 51.

tattoos to solidify their tribal bonds. The Makonde were known by other tribes for their raised facial tattoos that consisted of lines, bold angles, and chevrons sometimes stacked two or three in a row. They took pride in these raised designs, known as *dinembo,* that identified them as part of the Makonde tribe.

To make the dinembo, their tattoo artists used a process known as "skin-cutting," during which they would cut the skin of the face with a razor-sharp knife and then rub charcoal powder (made from burning the castor bean plant) into the wounds. Because there are so many more nerves in the face than in other areas of the body, tattooing the face tends to be agonizingly painful.

Many Makonde boys and girls getting their first tattoos—and knowing how painful it would be—were so frightened that they had to be held down by relatives. Lars Krutak lived for a short time among the Makonde; he interviewed older tribal members to find out what they recalled of traditional Makonde tattooing—which is no longer practiced. He writes, "I was told that boys and girls who attempted to run away while the cutting was taking place were some-times buried up to their necks in the earth, so that the tattoo artist could continue. . . !"[22]

After the cutting was completed, and once the sooty castor bean charcoal had been rubbed into the wounds, the newly tattooed Makonde would sit in the sun until the blood had dried. The whole process had to be repeated three more times, at six-month intervals, because the tattoos were intended to stand out from the skin. That meant that the tattoo artist would open the scars and rub more charcoal powder in the incisions. This would irritate the wounds and result in more prominent scarring—which was the goal. Makonde who did not return to get their tattoos redone were sometimes taunted by elders, who said that they were not true members of the tribe.

Religious Affiliations

Proclaiming one's affiliation with a particular religion has also been the motivation for tattoos. Rob Ludke, twenty-two, has a large tattoo of an angel on his right arm. He decided to get tattooed after he made the decision to join a church in Atlanta, Georgia. "I wasn't really brought up to be any religion," he says. "My parents weren't into it, so my sisters and I

weren't either. But I began attending a church when I was in college—just because my girlfriend attended—and I really liked it. The people were really welcoming and eager to make me feel like I belonged."[23]

Ludke says that being invited to join the church was an emotional experience for him, and those feelings preceded his getting a tattoo that takes up most of his right arm. "I just felt like I wanted a permanent symbol that will remind me that my faith needs to be permanent, too. It was a big step, and it was the right one for me."[24]

But religious tattoos have not always been an accepted form of expression. For centuries, Christian and Jewish leaders have banned tattoos, citing a passage in the Old Testament book of Leviticus (Vayikra in the Jewish Torah), "Ye shall not make any cuttings in your flesh for the dead, nor imprint any marks upon you: I am the Lord."[25] Muslims, too, were forbidden from getting tattoos because their religion does not permit them to cut or mutilate their bodies.

But even though tattooing was banned by religious leaders, it gradually gained acceptance by some Christian churches during the early Middle Ages. During this period, it was not uncommon for people to leave their farms or villages and make a pilgrimage to Jerusalem, a city they considered holy. There they found that Coptic priests had set up tattoo stalls outside Jerusalem's walls and offered pilgrims tattoo design choices of the cross, St. George slaying the dragon, or Mary with the infant Jesus. According to the website Vanishing Tattoo, "The tattoo designs were kept on woodblocks and the work was rough, but it was the only proof available that a pilgrim had actually visited the Holy Land."[26] By the eighth century BC, branches such as the Church of England had relaxed the ban on tattoos, announcing that tattoos that were related to Christianity were allowed.

Family Ties

Though tribal status and religion have long been celebrated with tattoos, some of the most common types of affiliation tattoos in the twenty-first century are those honoring one's family. Jon Rauch, a pitcher for the

New York Mets, has several familial tattoos. Not only does he have a tattoo of his wedding day—September 7, 2001—in large Roman numerals placed vertically down his back, but he also has a memento of his daughter's birth on the back of his right leg. He explains: "I had a little girl on December 6, [2006], Aubree Elizabeth. I've got her footprints and her name and birthday on my right calf. I took the piece of paper with the footprints from the hospital to the guy who does my [tattoos]. He did a stencil of that paper."[27]

Another family affiliation tattoo adorns the shoulder blade of twenty-year-old college student Jack Schneider. He made the decision to get a tattoo of the firefighter's badge belonging to his grandfather Tom Hall, a retired Minneapolis fire chief. "I'd thought about getting a tattoo for a long time," Schneider says. "But I never had any doubt about what my tattoo would be—my grandpa is really a huge part of my life."[28]

Schneider says that Hall means more to him than he could ever express, and that is why he decided on the tattoo. "He's always been there for me; he does so much—not only for me, really, but for everyone in

Many people choose tattoos to honor or remember family, as did this woman. Names or images that represent the family member are common.

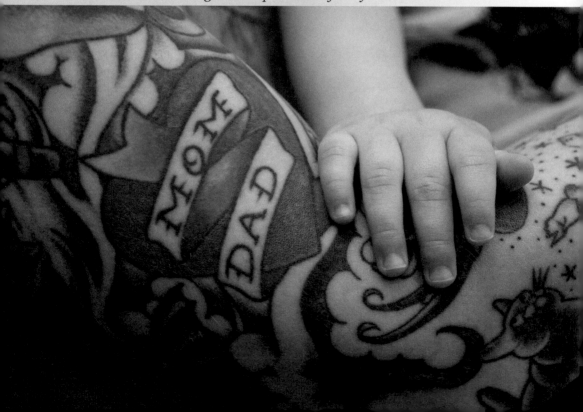

The Forbidden Tattoo

The Makonde people of Mozambique once prided themselves on the bold designs of the dinembo tattoo that set them apart from other tribes. However, the dinembo is one of the only tattoos in the world to have been officially banned by a government—in this case, the government of Mozambique.

Beginning in 1960, Mozambique's people fought a bloody revolution against the Portuguese who had colonized the country in the sixteenth century. The Makonde had fought side by side with those opposing the Portuguese, but when the new Socialist government of Mozambique took power, its members expressed concerns about the Makonde tribal tattoos. The distinctive raised designs of the dinembo tattoos set the Makonde apart from their countrymen. This presented a problem for those in the new government who wanted Mozambique to be a homogenous society. To deal with this concern, the government forbade the expression of individuality or allegiance to any tribe—especially the distinctive tattoo of the Makonde.

the community. So I borrowed his badge so the tattoo artist could copy it—and underneath the badge it says 'Big Tom.' Everyone in the family calls him that, because we've got lots of Toms in our family, and he's the oldest. He was really proud—and no, I haven't regretted it at all. My friends think it's amazing."[29]

Family Roots

Not all family affiliation tattoos are specific to a particular family member. Some demonstrate the connection to one's cultural heritage. For instance, when Julia Machindano, a Makonde woman from Mozambique, recently became engaged, she was determined to get the facial tattoos

that women of her culture once wore. Makonde tribal tattoos were out-lawed in Mozambique in the 1960s after a new government came to power, but she was able to find a tattoo artist in Denmark who was willing to accommodate her. Machindano says that the tattoo will have more far-reaching meaning than simply being marks on her forehead: "It symbolizes my peace of mind and personal freedom. I see my sisters and other Makonde women of my generation drifting away from this beautiful ritual tradition, which is tragic. I deeply admire the tattoo customs of my people and it was one of the many vehicles that they used to express and explain the ascending ladder of life and the relationships between the spiritual and physical world."[30]

Tattoos for Health and Good Luck

Since ancient times, many cultures have used tattoos as a way of ensuring good health and good luck. Often called "talisman tattoos," these markings are meant to ensure good luck to the wearer—whether in terms of health, love, hunting, or fishing, or in another aspect of life. For example, in the early twentieth century the Zuni culture in what is now New Mexico believed that specific tattoos could bring luck to young people. Both Zuni girls and boys had tattoos of stars, snakes, lightning bolts, lizards, and crow's feet on their arms and the backs of their hands to attract good fortune.

The Picts, who lived in what is now Scotland from about 7000 BC to AD 850, are believed to have used blue paint and colorful, full-body tattoos to bring them luck in battle. It was after the ancient Roman general Julius Caesar encountered Pictish warriors that he gave them the name, which means in Latin "tattooed or painted." In the early third century AD, the writer Solinus included this description of the Picts' body art: "That region is partly held by barbarians, who from childhood have different pictures of animals skillfully implanted on their bodies, so that as the man grows, so grow the marks painted on him; there is nothing more that they consider as a test of patience than to have their limbs soak up the maximum amount of dye through these permanent scars."[31]

Sailors' Tattoos

Cultural groups are not the only ones who have turned to tattoos for good luck and good health. Sailors, a traditionally superstitious group,

have long been associated with tattoos—especially those that offer hope of a safe voyage. For example, a compass tattooed on the inner forearm symbolizes the ability of seamen to safely find their way home. And a tattoo of a naked or partially clothed woman has long been associated with calming stormy seas and making the journey safer. In fact, many British sailing ships from the mid-sixteenth century onward had a wooden figure of a woman on the bow.

There are several tattoos that were believed to keep a sailor from drowning. A tattoo of a pig on a sailor's left ankle and a rooster on his right have long been considered good luck charms. Sailors might have believed that neither of these animals can swim, so if the ship foundered, some believed that the gods would take pity on the sailor with two such helpless animals on his body and help him get to shore. Another popular anti-drowning tattoo from an earlier time consisted of the letters H-O-L-D F-A-S-T inked across the fingers of both hands. If during a storm or other emergency a sailor was in danger of being swept overboard, it was believed that the message "Hold Fast" would help him grip the rigging long enough to survive.

New Yorker Ben Hoyt sports the "Hold Fast" tattoos, though he sails only for enjoyment. "I got it because it's one of the most vivid memories of my grandfather," he says.

> He was a Navy guy in World War II. I remember being at his house in Baltimore when I was about 10 or 11, and I was watching him play cards with three of his Navy buddies—all old guys. And I remember thinking, hey, all four of these guys had the same tattoos—"Hold Fast"—on their knuckles!
>
> I asked them how come they had the same message on their hands, and they told me that they had all gotten tattooed at the same time back in the 40s during the war. It made a big impression on me, and today, years later, that's the only tattoo I've got. I guess since it kept them all safe when there was a war going on, it might help me someday, too.[32]

Permanent Luck

Many people who get a tattoo for luck say that tattoos are infinitely better than a rabbit's foot, a lucky coin, or any other token that can be carried around. "The thing is, you can decide how big, what color—everything about your own personal lucky charm. And most important, you don't have to worry about losing the tattoo,"[33] says Jenny McMichael, who has an elephant tattoo on her left foot.

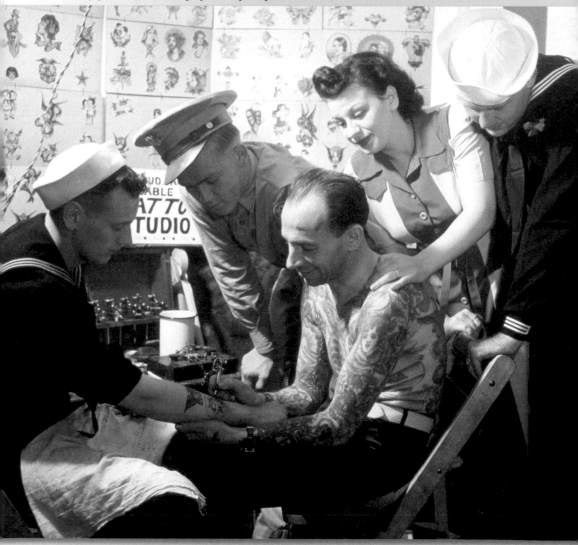

Friends watch as a young US sailor gets a tattoo in this colorized photograph from the 1940s. Throughout history, tattoos have had special meanings— mostly for luck and safe journeys—for sailors.

McMichael says that her elephant, whom she calls Roscoe, has helped her through graduate school, a difficult pregnancy, and even the death of her father in 2009. "I am the kind of person that needs a symbol, or something to transfer all my worried energy into," she says. "So the elephant is tactile; it's something I can run my finger across when I feel like I need a little calmness, a little peace when things are crazy or scary. I am convinced that Roscoe has given me that. It doesn't matter if it's just a psychological trick—this tattoo has helped me deal with a lot. And that's lucky for me."[34]

A New Type of Medical Tattooing

Tattoo artists sometimes use their skills to cover scars. Now, a group of skilled tattoo artists is finding a new, beneficial use for their art. It is called paramedical tattooing.

Tattooist Christine Gallowan works with patients in a doctor's office in Mentor, Ohio. She has created natural-looking eyebrows for a patient whose own eyebrows never grew back after chemotherapy. She has worked with a woman who suffered a stroke and whose facial features were no longer symmetrical. She has also created realistic skin tones on a patient whose skin condition left noticeable pale blotches. By paying close attention to each patient's skin pigment and hair shade, she uses her technical and artistic skills to make her work look entirely natural.

In her work with patients, she uses a style of needle different from the vibrating ones used by regular tattooists. While those can sometimes cause small tears in the skin, Gallowan uses needles that are thinner than a single strand of hair. Patients remark they feel like brushes rather than needles. Even more important, they say the process of getting a paramedical tattoo is life-changing. Said one of Gallowan's patients, "I feel like Christine has made me whole again."

Quoted in Evelyn Theiss, "Cosmetic Tattoos Help Clients Deal with Medical Maladies," *Clevland (OH) Plain Dealer*, December, 31, 2012. www.clevland.com

Ötzi the Iceman

With all of the power that many cultures have attributed to tattooing, it is not surprising that tattoos are also viewed as charms for good health. Anthropologists say that the earliest evidence of tattoos shows they were done to speed healing. Evidence of this practice surfaced in 1991 when two hikers came across the corpse of a man in the Ötzal Alps between Italy and Austria. The corpse, nicknamed Ötzi the Iceman by scientists, was so well preserved by a glacier that it still had skin on it. Scientific tests on the body determined that he had lived around 3300 BC and had likely died from a deep arrow wound in his shoulder.

One of the most fascinating things about Ötzi was the fifty-nine tattoos found on his body. They were not pictures but rather a series of dots and lines along both sides of his spine, as well as dots and other marks around his ankles and behind one knee. Scientists were baffled at first by the tattoos because they were on parts of the body that were usually covered—so it seemed highly unlikely that these were clan or tribal tattoos.

But after taking X-rays of the Iceman's bones, experts saw that he had suffered from severe arthritis in his back and knees, under the exact spots were the tattoos were found. This led to speculation that the tattoos might have been an effort to control his pain—similar to how acupuncture has been used in China for many centuries. Notes researcher John A. Rush, "The analysis of these tattoos strongly suggests that they were medicinal tattoos, possibly representing acupuncture points to relieve pain, but also for creating anesthesia, promoting endurance, and detoxification, to name a few possibilities."[35]

A Healthy Childbirth

There is also evidence that ancient Egyptians used tattoos to promote health. Only women were tattooed, and the usual reason for getting such a tattoo was to ensure that they would be able to bear children. Female mummies from about 2000 BC have elaborate patterns of lines and dots around their lower abdomen. Anthropologists theorize that

the tattoos were meant to symbolize a sort of net, which ancient Egyptians believed would protect the woman and her child during the birth process.

A few Egyptian mummies have been found with the symbol of the household god Bes tattooed on their thighs. The ancient Egyptians believed Bes attended each birth. By having his likeness tattooed on their bodies, Egyptian women hoped to gain the god's favor and enlist his help in keeping both the mother and child safe from evil spirits and danger.

Anthropologists are quite confident that they know the tattooing methods used by the ancient Egyptians. Archaeologists have uncovered what appear to be tattooing tools—very sharp points set into a wooden handle—which have been dated to about 3000 BC. In addition, they have found a set of tiny instruments that appear to be wide, flat needles that could easily have been used to create tattoos. Six or seven such needles bound together are used to create the pattern of dots found on tattooed women. Experts believe that black ink was likely a mixture of charcoal and blood or breast milk, which would make the ink liquid.

Forces for Fighting Pain and Danger

Some indigenous cultures in Canada and the United States have used tattoos to cure health problems or to ward off evil spirits. The Ojibwa of the upper midwestern region of the United States received special tattoos on their cheeks, temples, and foreheads to ease the pain of headaches and toothaches. During the tattoo process, other tribal members performed sacred dances and songs to help drive away the spirits causing the pain.

Among the Haida people of what is now Queen Charlotte Island in British Columbia in Canada, tattoos were believed to have the power to prevent dangerous accidents among this seagoing culture. In his 1872 book *Queen Charlotte Islands: A Narrative of Discovery and Adventure in the North Pacific*, explorer Francis Poole recounts his experience meeting a Haida woman, the daughter of the chief, with multiple tattoos. "She had half her body tattooed with representations of [various tribal] chiefs,

fish, birds, and beasts. She told me that a halibut laid open, with the face of the chief drawn on the tail, would protect her and her kin from drowning at sea."[36]

The early Hawaiians likewise had a tattoo to protect them from shark attacks. In 1923 newspaper publisher Lorrin Thurston met a Hawaiian woman with a row of tiny triangles around her ankle. She told Thurston that she had gotten the tattoo because of a legend about a lovely woman who had been bitten by a shark—which was her *amakua*, or sacred

The intricate shapes of a black-ink, Haida-style tattoo (pictured) were once thought to offer protection from accidents at sea. The Haida people tattooed their bodies with representations of fish, birds, and other creatures.

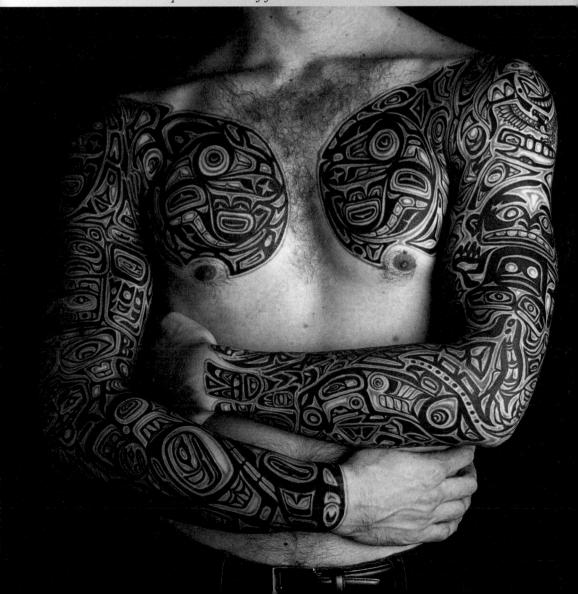

A Lucky Tattoo

When Roger Tichborne got a tattoo as a very young man, he could not have known how lucky that tattoo would be. The tattoo—which consisted of his initials, an image of an anchor, and a cross—saved his fortune from being stolen after his death. Tichborne was on his way to Jamaica in 1854 when the ship he was on was lost at sea. Though he was presumed dead, his mother continued for years to place ads in newspapers around the world, pleading for information about her son. In 1866 a man living under the name of Thomas Castro came forward; he falsely claimed to be Tichborne and demanded Tichborne's large fortune. Because there was considerable confusion and doubt about his claim, the courts got involved.

Castro had prepared for this scam by learning as much as he could about Tichborne's life, mannerisms, and other details. He told the court he had suffered amnesia, which accounted for his not coming forward earlier. However, the impostor's scheme fell apart when friends recalled that Tichborne had a large tattoo on his left arm—a detail Castro had missed. Though Castro tried to convince the judge that the amnesia had caused his tattoos to disappear, he was convicted of perpetrating a hoax, and spent the next twenty years in prison.

animal. Horrified, the legendary woman told the shark that he was supposed to protect her, not attack her. Apologizing, the shark let her go and promised that he would never make that mistake again, for he would see the marks of his teeth on her ankle.

Modern Medical Tattoos

Tattoos have also found a purpose in modern hospitals and cancer centers, though these tattoos are practical rather than spiritual. Before undergoing radiation therapy aimed at shrinking cancerous tumors, many

patients will be tattooed with small dots to pinpoint the exact location for the radiation treatments. As Jay R. Harris, professor of radiation oncology at Harvard Medical School, explains: "Most institutions do tattoos. And I know the term conjures up large roses, or other images. But in fact, the tattoos that are used are pinpoint marks, which mark the edges of the [radiation] field. In radiation therapy, one of the most important aspects of the treatment is precision. And the use of tattoos is an important aid in helping to make sure that your treatments are going to be done precisely, the same way each day."[37]

Sometimes people who must undergo an amputation opt to have a tattoo that ensures that the correct limb or body part is the one amputated. "I had heard stories about doctors removing the wrong limb, or the wrong kidney—scary stories," says patient John Iswold. "I'm sure it's quite rare, but if it happened to you, can you imagine how devastating it would be? I have diabetes, and was told that I had to have my left foot amputated because of complications of the disease. A few days beforehand, I had a tattoo done on my good foot, saying NOT THIS ONE! in big letters. Doctors are only human, and I didn't want to leave something that important to chance and have a mix-up on the operating table."[38]

Preventive Tattoos

In a rather recent development, some people who have a life-threatening condition are choosing to get tattoos to alert medical personnel if they are unconscious or injured and cannot speak for themselves. Matt Besley, an avid surfer, was diagnosed with type 1 diabetes as a boy. His doctors explained that if his blood sugar got too low because of the disease, he could become weak and even lose consciousness. Many diabetics wear a medical alert bracelet or necklace for such emergencies, but they did not work for Besley. "Over the course of my life I have had 10 or 15 bracelets, necklaces," says Besley, now an adult. "Surfing all the time I kept losing them."[39]

Eventually he decided to get a more permanent alert—a tattoo that identified him as a type 1 diabetic. Besley says that deciding on the best place for

the tattoo was critical. Emergency medical workers always look for the medical alert bracelets or necklaces, but would they find his tattoo if he was in such an emergency?

His decision was to have the tattoo with his health information on his forearm. "Two things are going to happen with a diabetic," Besley explains. "When you go into a hypoglycemic episode, they are going to put a dextrose IV in your arm and they are going to take your blood pressure. So they are going to have your arm out and exposed, so I figured that was a good place to put it."[40]

His assumptions were correct, for not long after getting his tattoo he had an episode in which he was very weak after surfing too long. "I started making my way into the shore," he says, "but I didn't have enough strength at that point because my blood sugar had gotten so low and I was kind of falling into the water."[41] Fortunately, witnesses saw that he needed help and pulled him ashore. When they pulled off his wetsuit they saw the tattoo. Lifeguards gave him a dextrose shot, and in a very short time his blood sugar levels had returned to normal.

Permanent Talismans

Evidence shows that since prehistoric times, people throughout the world have used tattoos to make them healthier and to offer them protection in war as well as good fortune in their voyages or hunting. In the twenty-first century, many people still put faith in lucky talismans in tattoo form, while others are still finding new ways that tattoos can be used in the medical field. The value of tattoos, whether for luck or good health, their value not only has a long and diverse history, but also a likely future.

Chapter Four

Beauty and Self-Expression

Some people decide to get a particular tattoo because it makes a statement about how they feel about themselves or how they want others to view them. When Iowa native Lynn Knapp went to college in New York, she wanted a tattoo to express who she was—not only to people she met, but to herself, too:

> I was a music major in college, and while I loved going to school in New York, for a long time I was really missing [our family] farm. So after thinking about it for a few months, I decided to get a tattoo that would express who I am, and at the same time, help ease the feelings of being so far from home. My tattoo is on my right upper arm, and it shows a little brown and white calf playing a violin. It's not cartoonish, but it's whimsical—it's perfect, and it makes the statement I wanted to make. I've never regretted it for a minute.[42]

Among the most common reasons given for wanting a tattoo are beauty or adornment and self-expression. The variety of such tattoos is infinite—ranging from a simple flower or word to an intricate design bathed in color and steeped in imagination.

Trends in Tattoos

Molly Fuller, the manager of a Minneapolis tattoo studio, says that a tattoo expressing a part of oneself is an extremely personal statement. "It basically says 'This is who I am, this is what I value or what is important

to me,'" she says. "And people have a lot of different things they want to express [with tattoos], but there are definitely trends with what our clients choose. Ten years ago, people would get a heart with 'MOM' on it, or an RIP [rest in peace] tattoo with a name. But now we're seeing more text than before—clients come in with phrases, even verses that they find really inspiring or meaningful."[43]

Fuller credits social media for making the idea of a tattoo seem more doable for people who might never have considered the idea before. "For example, there's a website called Pinterest, with lots and lots of ideas you can use. You basically build your collection, use the site's pictures and 'pin' them up on your own board and use them however you want. It gives people a lot of interesting ideas for tattoos. We have people coming in with the same Pinterest picture for a tattoo, so we know the site is popular."[44]

Fuller says that one of the most interesting tattoos her studio has done lately is a "rip-out" tattoo—the kind that looks as though an image is actually tearing out of the body. "The client was a really big guy, a military guy they all called Shrek," she remembers. "And that's the image he finally decided on—a big tattoo of the character Shrek's head and arms coming out of his chest. And that was a long process—I want to say between seven and ten three-hour sessions to do it. But he was happy, and it seemed to express who he was."[45]

Tattoos of Travels

For some people tattoos can be a virtual scrapbook of places they have visited, just as early pilgrims were tattooed when visiting Jerusalem or Mecca. Sailors, especially, were motivated to document their travels by tattoos in the years after explorer James Cook's eighteenth-century voyages. According to the website Vanishing Tattoo, by the early nineteenth century 90 percent of British and American sailors had tattoos, and the craze quickly spread until tattoo parlors became a staple of ports around the world.

The tattoos did not necessarily name the places visited but rather displayed a telling image. For example, a turtle showed that one had crossed the equator, a dragon showed the sailor had served in China, and a golden dragon was a way of bragging that he had crossed the International Date Line in his time at sea. A tattooed rope around the wrist showed the

The Most Beautiful Tattoos

Many tattoo aficionados maintain that the most beautiful style of tattoo is *tebori*, an ornate style of hand tattooing that originated in Japan. The tattooing culture of Japan is more than ten thousand years old, but tebori became especially popular in the early nineteenth century with the publication of a book of folktales. Inside were colorful, detailed woodcut prints of landscapes, dragons, tigers, and more. Soon after the book's publication, people began asking for tattoos of the illustrations.

The first to attempt these tattoos were woodblock artists, who found that their hammers and chisels worked on skin as well as on wood. Their tattoos were necessarily large because of the size of the tools. It was not uncommon for the designs to cover a client's upper body and even extend down the legs.

Over the years, tattooists found ways to use smaller tools to get the same results. With more than fifty types of handmade needles and a wide variety of colorful inks, tattooists practicing tebori have been creating styles that are admired throughout the world. However, tebori has become an endangered art. A tebori tattoo often takes hundreds of hours to complete and may cost the client as much as thirty thousand dollars. There are fewer tebori tattooists, too. As writer Clarissa Sebag-Montefiore notes, "With old masters passing away and young apprentices lacking the patience to learn the painstaking craft . . . many followers believe its days are numbered."

Clarissa Sebag-Montefiore, "The Dying Art of Hand Tattoo," *Los Angeles Times*, June 24, 2012.

sailor had been a deckhand, and a harpoon on his bicep meant that he was part of a fishing fleet. A bluebird tattooed on a sailor's chest showed he had five thousand sea miles under his belt.

A growing number of people today are using tattoos the same way. Londoner Taylor Bennett says he began getting tattoos when he visited Australia during college. "My tattoo is a colorful map of the country, which is still one of my favorites. I've been to America, China, and a bunch of European countries, and the first thing I do when I get to a new place is start investigating good tattoo studios. I look at the tattoos, and it's like I can remember what it felt like to be there."[46]

Expressions of Grief and Mourning

Tattoo professional Kore Grate says that recently the majority of her clients have wanted tattoos that express their love for a family member or friend who has died. "I think 70 percent of my business in the last month has been memorial tattoos," she says. "It might be just the name of the person who died, but often it's something that demonstrates the association to that person. I had someone who wanted a tattoo of a fishing lure, because that was a special bond he had with his father."[47]

Grate recalls a family who came in together after the death of their mother. They told her about how, on the day of her funeral, they had all seen a red dragonfly. "It was strange, because each of them saw that red dragonfly on that day, in all different places. It was as if that dragonfly was a way their mother was communicating with them, and that's how they saw it. So all six of them came in and wanted a red dragonfly tattoo."[48]

In many cases, Grate says, the process of getting a self-expression tattoo can be very emotional for the client. "It can be very healing, a way of satiating that ache of longing—and turns it into joy. . . . Tattooing can be part therapy. Getting that tattoo, it can shake stuff up inside; it's often not easy. So it's a real transformation. Sometimes people cry, hug me afterwards, and it takes a long time to say goodbye. They're so connected, so happy. They went through a final gate of something they've been hanging on to for a whole long time."[49]

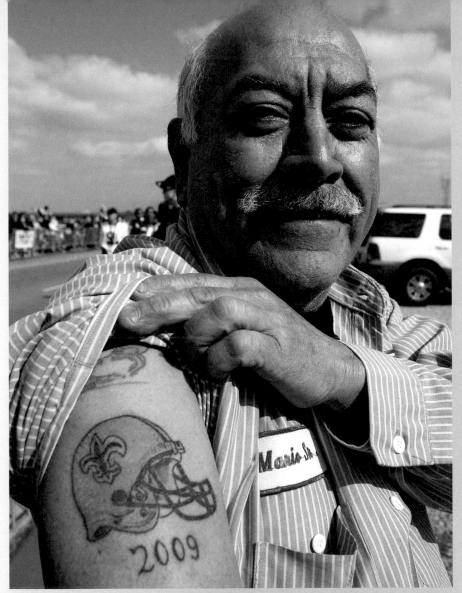

A New Orleans Saints fan shows his loyalty to the team with a tattooed image of the team's helmet and the year of the historic season that led to a Super Bowl victory for the Saints. Passions and pastimes often inspire the choice of tattoos.

Passions and Pastimes

Many people choose tattoos because of a passion for their hobby, job, or interest. Jeff Knutson, a lifelong Minnesota Vikings fan, has the team's logo on his left bicep. "I got it when I was twenty," he says now, at forty-seven. "Now that I'm older, it maybe feels kind of weird to still have it, especially since they haven't ever won a Super Bowl—but I haven't stopped being a

fan. Actually, my brother-in-law down in Chicago has a Cubs logo on his back—I tell him that he's even more pathetic than I am."[50]

A wide range of passions inspire body art. Bill Charson, sixty, recently got a tattoo—something he never believed he would do. "I've been a stamp collector since the age of eight," he says. "I get very excited

A Woman's *Moko* in the Twenty-First Century

In this excerpt from *Skin Stories: The Art and Culture of Polynesian Tattoo,* Manu Neho, a Maori woman from New Zealand, describes her very emotional experience of getting a traditional woman's *moko* in October 1999. The *moko* for Maori women has long been used to enhance beauty.

[First we had] a *wamea*—a time where we explain and learn about the history of *ta moko,* the process that will happen, and what is expected of those who come. So we had seventy people here. The majority were my family and very dear friends who came to support. And it was a time of celebration, because it was a revitalizing in our particular family of this art form which had almost died and has been revived, so it was a big celebration.

So the highs and the lows were just absolutely wonderful. And people sobbed their hearts out, and it was a huge cleansing of souls and cleansing of spirits, and cleansing of history. It was absolutely wonderful. I think it was my rebirthing. Because as I sat up after I had been completed, there was this overwhelming sense of rebirth. Just I sat up and the tears just flowed. I sobbed, literally sobbed as I held onto each one of those that were here to support. I just cried and we held each other.

Quoted in PBS, "Growing Up Maori," *Skin Stories: The Art and Culture of Polynesian Tattoo,* May 4, 2003. www.pbs.org.

about [George] Washington stamps. So in December 2011 I got a tattoo of a rare stamp I wish I owned—a 1910 two-cent George Washington that's worth about $2,500 today. The tattoo is great, and I've had lots of comments on it. I tell people the tattoo is as close as I'll ever come to having that stamp."[51]

A passion for science has led to some unusual tattoos. Sandeep Robert Datta, a professor at Harvard Medical School, has a tattoo of the DNA molecule, with his wife's initials cleverly hidden within the winding ladder shape. Carl Zimmer, author of *Science Ink: Tattoos of the Science Obsessed*, admired it, calling Datta's tattoo "a pure expression of geek love."[52]

Mark Yturralde, a self-described "space geek," was devastated after the 2003 *Columbia* space shuttle disaster in which all seven crew members were killed. He recalls that afterward he wanted to do something meaningful. Though he donated to college funds and other charities in their name, he still felt he had to do more. Yturralde made a list of those killed in the *Columbia* disaster and also the three astronauts who died in the 1967 fire during an Apollo I training exercise. That, he explains, is when the idea of a tattoo came to him: "It just struck me: I'll put their names on my forearm. People will see them. They'll ask who they are. I can then tell them about my tattoo, and what it means to me. Every time someone asks, and I explain it, they take a second. They reflect. They remember."[53]

Scientist Mitchell Fraller chose to get a tattoo showing a diagram of the molecular structure of a drug called phenobarbital. "My cat has epilepsy," he explains, "and I have to give her pheno twice a day to prevent her seizures. I also have a background in chemistry and biology, so this tattoo is a tribute to both my cat and the nerdiness of science in general."[54]

A Long History of Self-Expression

Getting a tattoo to express oneself is not limited to modern life. For instance, Hawaiian tattoos were traditionally intended to show one's tribal affiliation, but they were also frequently used to express grief at the passing

of a beloved family member or friend. Anthropologists have found that in Hawaiian culture of the eighteenth and nineteenth centuries, many people believed the tongue was the place on the body where grief was felt most acutely. For that reason, a person experiencing crippling grief sometimes chose to get a tongue tattoo—a particularly painful spot to be tattooed. The tongue tattoo was simple—no more than a dot or a line that was cut and inked with pigment. In addition to getting a tongue tattoo, a woman in mourning for her husband would get tattoos on her arms as well as the soles of her feet.

In the early 1820s Queen Kamamalu of Hawaii decided to get a tongue tattoo as an expression of her deep sadness after her mother-in-law died. A visiting missionary, William Ellis, had never before witnessed a tattooing and watched the queen's procedure with interest. He commented to her that it seemed she must be undergoing a great deal of pain. She replied, "He eha noi no, he nui roa ra ku'u aroha," which translates as, "Great pain indeed, but greater is my affection [for her]."[55]

Besides being used to express emotions such as grief and love, traditional tattoos were a popular way of enhancing one's beauty. Nineteenth-century French explorer Jacques Arago visited the Hawaiian Islands in 1819 and was particularly impressed with the women's tattoos. He made sketches of the process, noting the vast array of designs that made up the women's tattoos, especially those who performed hula dances. Arago wrote, "[They] make drawings of necklaces and garters on the skin in a manner really wonderful; their other devises consist of the horns, helmets, muskets, rings, but more particularly fans and goats."[56]

On the northern Japanese island of Hokkaido, the Ainu people believed that women's lips were a way of measuring beauty. For centuries, until the 1920s when the practice went out of fashion, girls as young as eleven years old would make the outline of their lips larger by tattooing beyond the natural margins until they looked like a clown's lips. As a girl grew into a young woman, she would gradually increase the width of her lips as well as tattoo them dark blue. By the time she was twenty-one her lips would extend almost as far as each ear.

Maori Tattoos

One of the world's most distinctive tattoo traditions is that of the Maori, an indigenous Polynesian culture on the island of New Zealand. The Maori tattoos, known as *ta moko*, or simply *moko*, were made up of bold black patterns of swirls and parallel lines that covered most of the face. These tattoos were done on the faces of Maori men. Cook saw Maori

The Maori people of New Zealand are well-known for the bold black swirling tattooed patterns that covered their faces. A watercolor portrait from around 1900 captures the intricate designs of Maori tattoos.

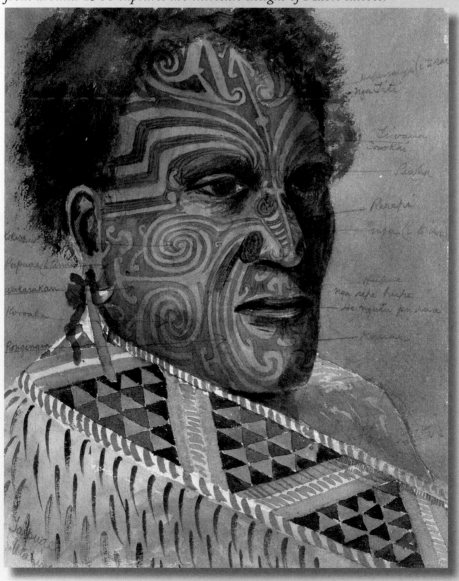

tattoos on his exploratory voyage to the Pacific in 1768. He describes the beautiful designs in his ship's log: "The marks in general are spirals drawn with great nicety and even elegance. One side corresponds with the other. The marks on the body resemble foliage in old chased ornaments, convolutions of filigree work, but in these they have such a luxury of forms that of a hundred which at first appeared exactly the same no two were formed alike on close examination."[57]

The most fascinating aspect of a man's moko was that each was unique. Though the swirls and lines on each man might look similar to the next, a closer inspection showed that they were actually as distinct as snowflakes. In fact, each Maori had every detail of his complex design memorized, and if he was required to sign a contract or any other document, he would draw his moko as his signature.

Cook learned that the moko made Maori men more fearsome to other tribes in battle, yet within the Maori culture it was a statement of fashion and personal accomplishment. The various patterns had meanings, depending on where they were placed. Ancestry was displayed on each side of the warrior's face—the father's on the left side, and the mother's on the right. Ornate, intricate designs symbolizing the warrior's own brave deeds were added to his face as they occurred.

A Difficult Ceremony

Joseph Banks, the naturalist who traveled with Cook on this voyage, reported on another big difference between the Maori tattoos and others they had seen in their travels. Banks wrote in his journal that "their faces [were] marked with deeply engraved furrows, also colored black, shaped as regular spirals."[58] In order to get these deeply engraved furrows, the tattoo artist used woodworking tools—a wooden hammer and a razor-sharp chisel made of bone. Though the gouging was painful, it was a point of pride for the warrior being tattooed not to flinch or to utter any sounds of pain. Often tribal flute players attended the moko ceremony and played calming music.

Did You Know?

In the eighteenth and nineteenth centuries Hawaiian tribal tattoos—including those of mourning, on the tongue—were done using sharp fish bones as needles.

Beautiful, Yet Sometimes Risky

One popular style of tattooing called *Kanji* uses Chinese letters to represent inspiring messages such as "love" or "trust yourself." Many feel the unusual lettering is more beautiful and eye-catching than a word written in English. But while the tattoo style is attractive, some have had unhappy results with it. British teen Lee Becks wanted a Kanji tattoo with the words "Love, Honor, Obey" written on his arm and was delighted the day he got the tattoo. However, when he walked into a Chinese take-out restaurant soon afterward, the woman serving him laughed at it, but was not comfortable telling him why. When he insisted, she told him that the words on his arm actually said, "At the end of the day, this is an ugly boy."

Mortified, Becks returned to the tattoo parlor only to find that it had closed. "He's a bit sensitive about the tattoos—they look very trendy if you don't know what they really mean," says Beck's employer Gary Doyle. "I don't think Lee stands much of a chance with any attractive young Chinese lady he may meet."

Realizing he had likely been the victim of a mean joke, Becks decided to get the tattoo surgically removed—at more than seven times what he paid to get it done in the first place.

Quoted in Georgina Littlejohn, "The Ugly Truth About This Badly Drawn Boy," *Metro* (London), June 6, 2002. http://metro.co.uk.

When the chiseling was complete, the tattoo artist used the chisel again, to lightly distribute the black pigment in each groove. The pigment used for coloring the moko had to be exactly right. The best pigment was made by taking wood ashes from various trees and mixing them with bird fat. The mixture was fed to a dog in the village, and its excrement was gathered and mixed with more bird fat. It was then dried and stored in ornate vessels that were buried until needed for the next tattoo ceremony.

Occasionally, the tattooist would hit the sharp chisel too hard, and would accidentally cut all the way through the facial skin, leaving small open slits. Witnesses described seeing tattooed Maori smoking ceremonial pipes, with smoke filtering through the slits in their cheek tattoos.

Moko in the Twenty-First Century

In modern times moko has enjoyed a new popularity as New Zealand's Maori population of 620,000 people have sought to reconnect with their ancestral roots. The traditional Maori designs are in high demand today, both among young Maori and those with no connection to the tribe. The traditional chisel and mallet have been replaced by modern tools, although some Maori see the new methods as compromising authenticity. "Today it is more likely that young people will acquire a machine-applied design," says Ngahuia Te Awekotuku, a Maori professor at the University of Waikato in New Zealand. "Many Maori families still refuse to consider needle tattooing as authentic for their culture."[59]

The idea of people who are not Maori getting the traditional moko tattoos is disturbing to some members of Maori society. They believe these tattoos are obtained without any real understanding of their meaning. When US boxer Mike Tyson got a moko tattoo on his face in 2011, many native Maori disapproved. They feel that the tattoos are an intensely personal statement for Maori, and that outsiders are appropriating an important part of the culture without fully appreciating the meaning. Pouroto Ngaropo, a member of the District Council in Whakatane, New Zealand, says some things are too important to misuse, noting, "The moko is by no means a fashion accessory."[60]

Awekotuku feels that no matter how it is used, it is crucial that people remember that moko is distinctly Maori. "The important reality remains—it is ours," she says. "It is about beauty, and desire, about identity and belonging. It is about us, the Maori people."[61]

A Glimpse of the Personality

Tattoos have long been a means for people to provide the world with a glimpse of who they are. For some, the tattoo is a way of showing how physically attractive they can be; for others it demonstrates whom they love or what they find most important in life. The range of emotions, the feelings and ideas people have inside are very personal. Tattoos are a window through which others can see a part of an individual.

The Dark Side of Tattoos

Throughout recorded history tattoos have been a source of pride, giving people permanent artistic ways to demonstrate their affiliations, to show their pride in the rites of passage within their culture, and to express the things that delight and interest them. But while they have played a crucial role in many cultures throughout the world, tattoos have a darker side. Over the course of history some have used tattoos as a means of controlling, threatening, and dehumanizing people.

Slaves and Outcasts

In ancient Rome tattoos were used to mark human property and to punish those accused of wrongdoing. Slaves were tattooed with a mark that identified them as the property of a specific owner in much the same way that American ranchers brand their cattle. The Romans also used tattoos reserved for the slave who committed a crime. For example, a slave who lied had the letters KAL (short for *kalumnia*, the Latin word for "lie") tattooed on his forehead. A slave caught stealing was marked on his forehead with the tattoo CF, which was an abbreviation for *cave furem*, meaning "beware the thief." And if the slave committed the crime of running away, his tattoo was FUG, short for *fugitivus*, the Latin word for "fugitive."

Slaves accused of crimes were not the only ones who were marked with tattoos. The ancient Greek philosopher Plato advised that anyone who robbed a temple should have a tattoo stating his crime displayed on his forehead and his hands. The Greeks followed his advice, as did the

Romans and other cultures throughout Europe in ancient times. John Zonare, a twelfth-century historian, reported that the Byzantine emperor Theophilus once took revenge on two monks for publicly criticizing him by having eleven verses of obscene poetry tattooed on their foreheads.

Did You Know?

Stigma is the word used by the ancient Romans for "tattoo"; *stigma* now means "a mark of disgrace."

The first accounts of Hawaiian tattooing practices were those of James Cook in the late 1700s. Hawaiians historically used tattoos as punishments or to identify a person who was an outcast from society. Typical tattoos for such people were a curved line just above the bridge of the nose or a round spot in the middle of the forehead. Stories of prisoners taken by the Hawaiians in war suggest that those captives were marked with tattoos. In what was assuredly a painful ordeal known as *maka uhi*, the Hawaiian fighters would turn the captured warrior's eyelids up, and tattoo designs on the inside—a mark of the highest humiliation.

Nazi Tattooing

One of the most reprehensible uses of tattooing took place during the Holocaust when Germany's Nazi regime systematically murdered 6 million Jews and others they believed to be inferior. Beginning in 1941 at prison camps in Auschwitz, Poland, prisoners were forcibly tattooed with a number to make it easier for the Nazis to track and identify them. For the Jews, the forced tattooing was especially traumatic, for their faith forbids them to get tattoos. For centuries, Jews had been told by rabbis that if they had a tattoo they could not be buried in a Jewish cemetery.

According to the United States Memorial Holocaust Museum, the first prisoners were tattooed on the chest:

Originally, a special metal stamp, holding interchangeable numbers made up of needles approximately one centimeter long was used. This allowed the whole serial number to be punched at one blow onto the prisoner's left upper chest. Ink was then rubbed into the bleeding wound. When the metal stamp method proved impractical, a single-needle device was introduced, which pierced the outlines of the serial-number digits onto the skin. The site of the tattoo was changed to the outer side of the left forearm.[62]

"A Deep Wound"

Some survivors of the concentration camps were eager to be rid of their tattoos, for they were obvious reminders of a horrific time. Over the years they had them surgically removed or got a new tattoo to mask the hated numbers. "I have covered up those numbers," says Kore Grate. "I've found that during the procedure, [the people] don't talk much. I tell them, 'I know it's a deep wound, and it's powerful what you must be feeling.' They want to think ahead, though, not back. They've told me it's a transformation, a metamorphosis. I love doing that, taking something

The Nazis tattooed identification numbers on the forearms of Jews forced into concentration camps. The tattoo shown here belongs to a survivor of the Auschwitz concentration camp.

you don't like, and have something that gives you pleasure. I felt honored at those times."[63]

Sadie, whose mother, Rivka, was a survivor, recalls that for many years the tattoo was never discussed in their home. "She would not talk about it. My mother would just make that 'tch, tch, tch' noise when we would ask about those greenish numbers," Sadie says. "My sisters and I all wanted to know—was it a telephone number, was it a bank number? But she always said it was better that story went untold. We were very young, and were curious why anyone would want numbers on their arm, you know? We found out by the time the youngest of us was 12 or 13, and it made us so sad to think she had had such an experience."[64]

The survivors dealt with the permanent reminders in very different ways. Many responded like Rivka, not talking about the tattoos or hiding them under long-sleeved clothing, even in summer. Others viewed their tattoos as important reminders of events that should never be forgotten. As Jewish Italian writer Primo Levi, a Holocaust survivor, explains: "With time, my tattoo has become a part of my body. I do not display and do not hide it. I show it unwillingly to those who ask out of curiosity, readily and with anger to those who say they are incredulous. Often, young people ask me why I don't have it erased. This surprises me: Why should I? There are not many of us in the world to bear this witness."[65]

Taking Their Grandparents' Numbers

In recent years the descendants of some Holocaust survivors have found new ways to keep the memory of the Holocaust genocide alive. One survivor of Auschwitz, Yosef Diamant, was recently astonished when his seventeen-year-old granddaughter, Eli Sagir of Jerusalem, Israel, showed him her new tattoo. It was his tattoo number, now inked on her own forearm. She did it, she says, because she worries that young Israelis of her generation are unaware of a very important part of their history. "All my generation knows nothing about the Holocaust," says Sagir, now a twenty-one-year-old. "You talk with people and they think it's like the

> **Did You Know?**
> California governor Jerry Brown signed a bill in 2012 allowing former victims of human trafficking to get the tattoos forced on them by pimps and traffickers removed at state expense.

Exodus from Egypt, ancient history. I decided to do it to remind my generation: I want to tell them my grandfather's story and the Holocaust story."[66]

Others have done the same and for similar reasons. "We are moving from lived memory to historical memory," says Michael Berenbaum, a noted Holocaust scholar. "We're at that transition, and this is sort of a brazen, in-your-face way of bridging it."[67]

Some of the survivors whose descendants have adopted their tattoos are upset at first. They say they had hoped that the revulsion and dehumanization they had felt when they got the tattoo would never touch

their children or grandchildren. But after awhile, most are touched by the gesture, as was Yosef Diamant, who kissed his granddaughter's tattoo when she showed it to him.

New Yorker Edward Hochman says that the new tattooing among some younger Jews is remarkable in the way it is transforming the whole idea of the Holo-caust tattoo: "When I was a boy in the 1960s, there was an expression 'long sleeves in the summer.' It referred to Holocaust survivors who were so ashamed of their death camp tattoos that no matter how hot the weather became, they would not wear shirts that exposed their forearms. It is inspiring to see how the grandchildren of those Holocaust survivors have turned a mark of shame and suffering into one of pride and remembrance."[68]

Did You Know?

In seventeenth century Japan, outcasts from society were tattooed on their forearms—with either a cross or a line.

Tattoos and Human Trafficking

Though tattoos are not used to dehumanize people on that scale today, there are still some people who routinely force tattoos on others to both control and demean them. Many human traffickers and pimps make large amounts of money by selling women and girls into forced labor as prostitutes. In 2012 *New York Times* reporter Nicholas Kristof reported on the way they force their victims to be tattooed.

Taz, a 16-year-old girl here in New York City, told me that her pimp had branded three other girls with tattoos bearing his name. When she refused the tattoo, she says, he held her down and carved his name on her back with a safety pin . . . [and] an alleged pimp indicted last month in Manhattan is accused of tattooing his street name on a prostitute's neck, along with a bar code. He allegedly tattooed another prostitute with a symbol of his name on her pubic area, along with a dollar sign. In each case the message was clear: They were his property, and they were for sale.[69]

According to the Polaris Project, a group dedicated to combating human trafficking around the world, Kristof's observation was not un-common. Between 2007 and 2012 more than 28 percent of callers to the National Human Trafficking Resource Center Hotline attested that they

had seen a trafficker's name or symbol on a victim's body, and many say that the tattoos had been forced on the victim.

This is not only a US problem—rather, it is one seen around the world. For example, in Madrid, Spain, in March 2012, a national police investigation into human trafficking rings led to the rescue of a captive teen. She had tried to escape from her pimps, but they caught her and forcibly tattooed a barcode on her wrist. Underneath the barcode was a tattoo showing the amount of money they insisted that she owed the trafficking ring.

Tattoos and US Prison Culture

In many countries, including the United States, prison inmates are barred from getting tattoos while in custody. Prison officials say that the biggest reason for the regulation is to avoid spreading disease. As of 2011 an estimated 2.2 million American inmates tested positive for the blood disease hepatitis C, and another twenty-nine thousand are reportedly infected with HIV. Both of these diseases are spread through the use of unsanitary needles.

Even though it is forbidden, however, in most prisons tattooing is a frequent occurrence, so a reasonably talented tattoo artist can be busy. Some convicts choose to get a tattoo to express pride in their race or gang affiliation. Others may choose a picture of a wife or girlfriend. Still others decide on a threatening tattoo to make themselves appear tough, as a way of discouraging bullies or sexual predators.

"Sometimes it's just a lot of time on their hands, and they want to look tough," says one former prison worker. "There are also a lot of them that have religious images on their backs and chests, you know, Jesus and Mary, the cross. You've got some guys who have Muslim symbols, too. Some of the guys were pretty much running out of skin, the ones who'd been in there the longest."[70]

Makeshift Tattoo Tools

Because prison tattooists do not have access to professional tattoo guns or other supplies, they must rely on homemade methods. Tattoo ink is

usually made from burning oily substances like baby oil or Vaseline or plastics, such as disposable razors. The soot from these materials is added to water and a bit of soap, and the ink is ready to use.

The tattoo gun is often more difficult to assemble. Some have been made from parts of electric razors or portable radios and empty plastic ink barrels inside of ballpoint pens. The needles used are often hairbrush bristles or sometimes pieces of wire—sharpened to a fine point—cut from the prisoner's window screen.

One prison tattooist says that he has actually had luck getting some materials from within the prison that can keep the process more sanitary.

A Washington corrections officer displays a homemade tattoo gun and other items confiscated from a prison inmate. Inmates tattoo each other with devices made from small motors attached to a needle that is dipped into ink taken from a ballpoint pen.

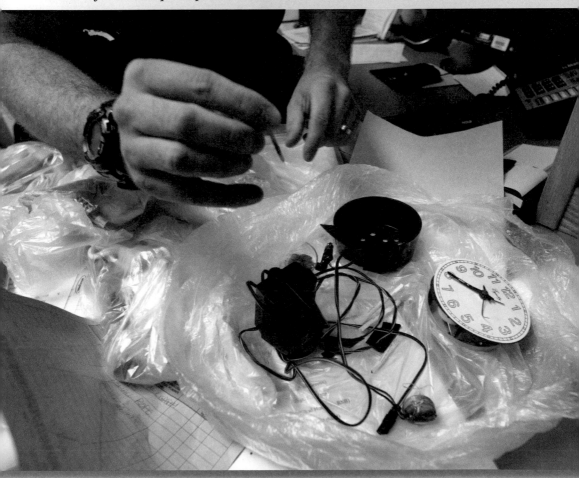

"Scoring chemicals such as powdered bleach and latex gloves is a challenge, but it isn't impossible, especially if the artist maintains a good relationship with both officers and convicts alike. Tattooing in prison is all about connections."[71]

Another prison tattooist at the California State Prison in Solano County explains that he gets paid, but like any tattooist in prison, he must be flexible. Since so many convicts have little or no money, he explains, he cannot charge a regular rate. "I work on the basis that all money is good money. I accept stamps, cosmetics, whatever. . . . If I do a full back piece [tattoo], in here I charge anywhere from $100 to $200. But I work out payments for people." He also prides himself on being as sanitary as possible in what could be very difficult conditions. "I

Heads for a Price

The European sailors who first arrived in New Zealand were fascinated by the moko tattoos of the Maori. They were also intrigued by the Maori custom of keeping the heads of enemies killed in battle, as well as the heads of their own family members after they died. The heads were kept in special boxes and brought out during important ceremonies. However, the Europeans' avid interest would have deadly results for the Maori culture.

It did not take long for European traders to realize they could sell these exotically tattooed heads for high prices back home. By the early nineteenth century, the Europeans were trading guns for as many heads as the Maori could supply. Eager to possess those guns, the Maori began raiding neighboring villages, killing warriors and others for their heads. The Maori eventually tried to use those guns on the British, who had appropriated much of their land. Outgunned by the better-armed British troops, the Maori lost all of their land—as well as their interest in tattooing and other traditional aspects of their culture.

use equipment on one person only," he says. "I use the same motor and so forth, but it's all different needles and barrels, and all new ink."[72]

Threats Via Tattoo?

In some situations tattoos have been used to threaten others with bodily harm. In November 2012 the district attorney for Hennepin County in Minnesota charged that a graphic tattoo—along with a Facebook post—had been used to make terroristic threats against a Minneapolis police officer. The tattoo belongs to a twenty-year-old gang member, Antonio Jenkins Jr., who has a tattoo on his bicep of a person described by the Minneapolis *StarTribune* as "holding a semi-automatic handgun with the barrel of the gun partly in the mouth of a pig."[73] The tattoo includes the officer's badge number as well as his name (misspelled), with an expletive directed at police. On Jenkins's Facebook page he includes a message about the image: "My tattoo iz a pig get'n his brains blew out."[74]

Jenkins was arrested for making threats against the officer, but the American Civil Liberties Union disagrees with the arrest, saying that free speech is guaranteed under the Constitution. "This is the United States of America, and we have a Bill of Rights, and that's a messy thing oftentimes,"[75] says Chuck Samuelson, executive director of the ACLU.

The police officer, a twenty-two-year veteran of the force, works in a part of the city that is often claimed to belong to the Bloods gang. The officer believes the tattoo is a direct threat and says his family is in fear for their safety as a result of Jenkins' tattoo and his Facebook page.

When the issue is eventually resolved, it will be interesting to many. Can a tattoo be considered a threat? Or is the message inked on skin protected by the Constitution as free speech? Whatever the outcome of this particular case, it demonstrates yet another example of the power of tattoos.

A Power in Permanence

Since prehistoric times, cultures throughout the world have used tattoos as a means of beautifying themselves, paying homage to powerful gods

and beloved family members, and protecting themselves from the dangers surrounding them. Many have used tattoos as a means of showing the world who they are and what they believe in. And though the reasons for tattooing vary, it seems that, as tattoo historian Steve Gilbert notes, there was a power in the very permanence of "puncturing the skin, letting blood, and consenting to change the body for life."[76] That power is something that has fascinated humans for thousands of years.

Source Notes

Introduction: An Enduring Tradition

1. Suzanne Kennedy, personal interview with author, November 16, 2012, St. Paul, MN.

2. Chico Mason, telephone interview with author, November 10, 2012.

3. Quoted in Columbia University Press, "Interview with Juniper Ellis, Author [of] *Tattooing the Skin: Pacific Designs in Print and Skin,*" n.d. http://cup.columbia.edu.

4. Quoted in Caitlin A. Johnson, *The Early Show,* CBS News, "Tattoos Becoming More Accepted at Work," CBS News, February 11, 2009. www.cbsnews.com.

Chapter One: Marking Life's Transitions

5. Lars Krutak, "Scarification and Tattooing in Benin: The Bétamarribé Tribe of the Atakora Mountains," 2008. www.larskrutak.com.

6. Krutak, "Scarification and Tattooing in Benin."

7. Quoted in Krutak, "Scarification and Tattooing in Benin."

8. Maarten Hesselt van Dinter, *The World of Tattoo: An Illustrated History.* Amsterdam: KIT, 2005.

9. W.D. Hambly, *The History of Tattooing and Its Significance.* London: H.F. & G. Witherby, 1925, p. 51.

10. Holly Lidecker, personal interview with author, December 2, 2012, Minneapolis, MN.

11. Bergen Olson, telephone interview with author, December 4, 2012.

12. Quoted in PBS, "A Beautiful Tattoo Hides a Secret," *Skin Stories: The Art and Culture of Polynesian Tattoo.* www.pbs.org.

13. Quoted in "A Beautiful Tattoo Hides a Secret."

Chapter Two: Tattoos of Belonging

14. Flynn, telephone interview with author, November 22, 2012.

15. Quoted in "Ice Mummies: Siberian Ice Maiden," *NOVA*, November 24, 1998. www.pbs.org.

16. Quoted in Cate Lineberry, "Tattoos: The Ancient and Mysterious History," *Smithsonian Magazine*, January 1, 2007. www.smithsonianmag.com.

17. Quoted in van Dinter, *The World of Tattoo: An Illustrated History*, p. 263.

18. Quoted in Max Wright, telephone interview with author, December 4, 2012.

19. Quoted in A.T. Sinclair, "Tattooing of the North American Indians," *American Anthropologist*, 1909, p. 364. http://onlinelibrary.wiley.com.

20. Quoted in Steve Gilbert, *Tattoo History: A Source Book; An Anthology of Historical Records of Tattooing Throughout the World*. New York: Juno, 2000, p. 89.

21. Quoted in van Dinter, *The World of Tattoo*, p. 237.

22. Quoted in Eleanor Goodman, ed., "The Tattoo Tourist," *Body Art 3*. London: Titan, 2012, p. 109.

23. Rob Ludke, personal interview with author, November 28, 2012, Minneapolis, MN.

24. Ludke, personal interview.

25. Leviticus 19:28.

26. The Vanishing Tattoo, "Tattoos and Religion." www.vanishingtattoo.com.

27. Quoted in Ben Reiter, "Art of Pitching: A Reliever's Body Is His Bio," SI.Com, April 16, 2007. http://sportsillustrated.cnn.com.

28. Jack Schneider, telephone interview with author, November 23, 2012.

29. Schneider, telephone interview.

30. Quoted in Lars Krutak, "Colin Dale and the 'Forbidden Tattoo,'" 2010. www.larskrutak.com.

Chapter Three: Tattoos for Health and Good Luck

31. Quoted in Richard Dibon-Smith, "The Pictish Tattoo: Origins of a Myth," p. 95. www.dibonsmith.com.

32. Ben Hoyt, telephone interview with author, November 18, 2012.

33. Jenny McMichael, personal interview with author, December 1, 2012, Richfield, MN.

34. McMichael, personal interview.

35. John A. Rush, *Spiritual Tattoo: A Cultural History of Tattooing, Piercing, Scarification, Branding, and Implants*. Berkeley, CA: Frog, 2005, p. 26.

36. Quoted in Sinclair, "Tattooing of the North American Indians," p. 377.

37. Quoted in ABC News, "Why Are Tattoos Used in Radiation Treatment Planning, and Are They Permanent?," ABC News, May 8, 2008. http://abcnews.go.com.

38. John Iswold, telephone interview with author, December 3, 2012.

39. Quoted in Megan Coleman, "Why Are People Getting Tattoos for Medical Reasons?," CNY Central, March 15, 2012. www.cnycentral.com.

40. Quoted in Coleman, "Why Are People Getting Tattoos for Medical Reasons?"

41. Quoted in Coleman, "Why Are People Getting Tattoos for Medical Reasons?"

Chapter Four: Beauty and Self-Expression

42. Lynn Knapp, personal interview with author, December 10, 2012, Minneapolis, MN.

43. Molly Fuller, personal interview with author, December 10, 2012, Minneapolis, MN.

44. Fuller, personal interview.

45. Fuller, personal interview.

46. Taylor Bennett, telephone interview with author, November 27, 2012, St. Louis Park, MN.

47. Kore Grate, personal interview with author, November 2, 2012, Minneapolis, MN

48. Grate, personal interview.

49. Grate, personal interview.

50. Jeff Knutson, telephone interview with author, October 31, 2012.

51. Bill Charson, personal interview with author, November 1, 2012, Hopkins, MN.

52. Quoted in Carl Zimmer, *Science Ink: Tattoos of the Science Obsessed*. New York: Sterling, 2011, p. xi.

53. Quoted in Zimmer, *Science Ink*, p. 77.

54. Quoted in Zimmer, *Science Ink*, p. 51.

55. Quoted in Betty Fullard-Leo, "Body Art," *Coffee Times,* Spring/Summer 1999. http://coffeetimes.com.

56. Quoted in Betty Fullard-Leo, "Body Art."

57. The Vanishing Tattoo, "The Maori/New Zealand." www.vanishingtattoo.com.

58. Quoted in van Dinter, *The World of Tattoo*, p. 143.

59. Ngahuia Te Awekotuku, "The Rise of the Maori Tribal Tattoo," *BBC News Magazine*, September 20, 2012. www.bbc.co.uk.

60. Quoted in Ta Moko, "Tattooing." http://awanderingminstreli.tripod.com.

61. Awekotuku, "The Rise of the Maori Tribal Tattoo."

Chapter Five: The Dark Side of Tattoos

62. United States Holocaust Memorial Museum, "Tattoos and Numbers: The System of Identifying Prisoners at Auschwitz." www.ushmm.org.

63. Grate, personal interview.

64. Sadie, personal interview with author, December 7, 2012, St. Louis Park, MN.

65. Quoted in Olga Gershenson, "An Indelible Legacy," *Jewish Daily Forward* (New York, NY), August 20, 2012. http://forward.com.

66. Quoted in Jodi Rudoren, "Proudly Bearing Elders' Scars, Their Skin Says 'Never Forget,'" *New York Times*, September 30, 2012. www.nytimes.com.

67. Quoted in Rudoren, "Proudly Bearing Elders' Scars."

68. Edward Hochman, "A Tattoo, to Remember the Holocaust," letter to the editor, *New York Times*, October 8, 2012. www.nytimes.com.

69. Nicholas Kristof, "She Has a Pimp's Name Etched on Her," *New York Times*, May 23, 2012. www.nytimes.com.

70. Del, telephone interview with author, November 29, 2012.

71. ConvictedArtist.com, "Prison Tattoos." www.convictedartist.com.

72. Clarence Ashby, interview by Ted Koppel, "Prison Tattoos," *Koppel on Discovery*, May 1, 2009. www.tv.com.

73. Quoted in Mary Lynn Smith and Randy Furst, "Tattoo on Facebook Aimed at Cop Lands Gang Member in Jail," *Minneapolis (MN) Star Tribune*, November 9, 2012. www.startribune.com.

74. Quoted in Smith and Furst, "Tattoo on Facebook Aimed at Cop."

75. Quoted in Smith and Furst, "Tattoo on Facebook Aimed at Cop."

76. Steve Gilbert, *The Tattoo History: A Source Book*, New York: Juno, 2000, p. 9.

Books

Diane Bailey, *Tattoo Art Around the World*. New York: Rosen, 2012.

Lal Hardy, *The Mammoth Book of Tattoos*. Philadelphia, PA: Running Press, 2009.

Stephen Feinstein, *Captain Cook: Great Explorer of the Pacific*. Berkeley Heights, NJ: Enslow, 2010.

Jeanne Nagle, *Why People Get Tattoos and Other Body Art*. New York: Rosen, 2012.

Maarten Hesselt van Dinter, *The World of Tattoo: An Illustrated History*. Amsterdam: KIT, 2005.

Carl Zimmer, *Science Ink: Tattoos of the Science Obsessed*. New York: Sterling, 2011.

Internet Sources

Lina Goldberg, "Gang Tattoos: Signs of Belonging and the Transience of Signs," Vanishing Tattoo. www.linagoldberg.com/gangtattoos.

Cate Lineberry, "Tattoos: The Ancient and Mysterious History," *Smithsonian Magazine*, January 1, 2007. www.smithsonianmag.com /history-archaeology/tattoo.html.

Meghan Smith, "History of Tattooing," How Stuff Works: TLC Style. http://tlc.howstuffworks.com/style/body-art/history-of-tattooing .htm.

Websites

How Tattoos Work (http://health.howstuffworks.com/skin-care /beauty/skin-and-lifestyle/tattoo.htm). This website by Discovery Health features a step-by-step introduction to the tattoo process. There are chapters on creating tattoos, finding a reputable tattoo par-

lor, using shade and color, and a well-illustrated section on how tattooing works.

Skin Stories (www.pbs.org/skinstories). This PBS website is an anthology of tattoo images and personal stories of the most talented tattooists and of people all over the world who have decided to get tattoos.

Strike the Box (www.strikethebox.com/index.htm). Strike the Box is dedicated to the tattoo art of firefighters. Particularly interesting is the wide range of 9/11 tattoos by New York City firefighters, who lost so many of their own that day.

Index

Picture Credits

Cover: © Markus Cuff/Corbis, Thinkstock Images

AP Images: 18, 24, 47, 63

© Bettmann/Corbis: 35

© Marcus Cuff/Corbis: 39

© Peter Johnson/Corbis: 13

© Vincent Kessler/Corbis: 58

© Luca Tettoni/Corbis: 8

Thinkstock Images: 30

Tapuae, c. 1900 (w/c on paper), Ryan, Thomas (1864-1927)/Private Collection/©Michael Graham-Stewart/The Bridgman Art Library: 51

Gail Stewart is the author of more than 250 books for children, teens, and young adults. She lives in Minneapolis with her husband, Carl, and is the mother of three grown sons—Theo, Elliot, and Flynn.